Calling hope

NWACHUKWU MANI OKONKWO

authorHOUSE®

AuthorHouse™ UK Ltd.
500 Avebury Boulevard
Central Milton Keynes, MK9 2BE
www.authorhouse.co.uk
Phone: 08001974150

First published by AuthorHouse 7/28/2011

ISBN: 978-1-4567-8107-1 (sc)
ISBN: 978-1-4567-8108-8 (e)

Table of Contents

Verse .. 1

Wish ... 2

Still .. 3

Me .. 4

Always ... 5

Keeping On ... 6

Mirror .. 7

Foam .. 8

You ... 9

Great .. 10

What .. 11

Now .. 12

Late .. 13

Reality .. 14

Not Always .. 15

Hunter ... 16

Flying ... 17

On .. 18

Call .. 19

Celebrate ... 20

Fool .. 21

Why .. 22

Goodness ... 23

Hope .. 24

Chance ... 25

Waiting .. 26

Will .. 27

You ... 28

Joy .. 29

Point .. 30

Wing .. 31
Fair ... 32
Be .. 33
Trade ... 34
Pride .. 35
Don't .. 36
Again ... 37
Feel ... 38
Nothing .. 39
Choice .. 40
On .. 41
Sweet ... 42
Angle .. 43
Quest .. 44
Seed ... 45
Temtetion .. 46
Comfort ... 47
Design .. 48
Overlook .. 49
Planned ... 50
Peace .. 51
Compaer .. 52
Hate ... 53
Letting Go .. 54
Ask .. 55
Hold ... 56
Me ... 57

Verse

I can never stop writing to you
In you there is always a sentence
Once I call your name
One line will follow
Two
Three
On and on it will flow
Love verse
Peace word
Joy verse
An unending love song
My soul will then be at peace
Because you are and will always be
My verse of joy and hope

Wish

If only I have a wing
Wish I can be carried by the wind
Be a fish as to be flown through the ocean
To get close to you
Nothing hurts like the missing of a love one
Mostly when the force hindering one
One cant control
Here I am today
Had hope to be there yesterday
Still my love is the same
Strong unshakable
Knowing what ever way
By tomorrow I will be there holding your hand saying
Is still me
I love you

Still

I see you as I close my eyes
Asleep I am not
Just to see you
Hold you
Feel you
Because you live in me
This beyond dreams
Fiscally I can't touch you
But as I feel you I touch you
See you
Even when my eyes are open
I touch you
Being a reality in me
What more can I ask
Than this reaching out soul

Me

It will always be me
Still me
I have been hit hard
Lost everything
Even control of myself
But it's still me
don't turn your back on me
It is me with little or nothing to offer now
Tomorrow will come and favour will find me
Then I will play myself again

Always

Life is everyday celebration
As we live on hope
Hope on love
Love as to be joyful
Joyful as to have peace
Peace as to move forward
forward
 To fine our needs
Which comes without
 Asking why me
It will always be someone
Life is all about patience
Endurance.

Keeping On

It's not just about now
What one past or going through
It's about tomorrow
For one thing that is not still in life is change

Mirror

If as a mirror you see yourself through everyday
I will not only show how beautiful you are
I will shout your beauty that goes
beyond the fiscal down to the soul
Moves of your hands that can turn
nothing into something
Your back that carries others along
when even yourself is not steady
Carry on you are one in a million
No matter what you are going through
now your beauty never fade abet
For it's real

Foam

It may not have been as we wanted
Hardly has it been as one wants
What matter is we have each other
Laugh now
Love comes in deferent foams
The joy it keeps on
Courage that it gives
The hope it restore
Life it sustains
Are beyond sex and touch

You

Because I have you
I can walk on top of water
And will not be drown
With only a branch
I can swipe the world to our feet
I know you know what a miracle you are to me
Making my impossible possible
But I must say it to you
Letting the world know
You are my lucky charm

Great

Is it not great
How you always make me laugh
Killing all my sadness
I owe you one
Meaning I owe you all
Because that one
Is life itself

What

What a fate
Having so much faith
Hoping this is it
Taking a dive
A dive again
Only to see all gathered
Scattered by breeze
Forcing the word why me
This many have ask
Wheel of fate
It roll matters not
It will always roll
But keeping on diving
To force a change.

Now

I will not regret now
Saying why did I not go with the first wind
Who can tell where it will go
Its movement is prediction
What it will come against unsure
When it will stop uncertain as its strength
Hopefulness the only answer
Helping to clear tears from the pains of the bruises
To see when good break will come.

Late

How will
 I not have seen it
When it shines out
What must have gone wrong
When that was what I have been in search for
Way to my success
My joy
My future
Hope I am not late
It may not come again.

Reality

I ran down the road
 Taking cover under flower trees
 Hoping it will shield me from the harshness of life
 Still it came as a heavy wind
 Blowing against the leaves
 Making it wave
 Whispering
 Open your eyes
 Look front some are crying
 Look your back others are laughing
 Your right some are leaping
 Left others are walking
 Some laughing today may
 be crying tomorrow
 Those crying now may be
 laughing in the next hour
 Some walking now may be
 leaping tomorrow
 Those leaping this hour may be
 walking as the day break
 This reality of life
 Everyone has his day

Not Always

I danced as I was told
Singing along with the redeem
Then I stop
Why should I be told to dance
Command to sing
It was almost over
Then I realized
The dance would have kept me fit
Song new hope
Knowing now it's better to think first
Before acting

Hunter

A hunter I am
Killing lions
Elephants run on hearing my footstep
The ray from my head touch light frighten tigers
Bush pigs run for cover sighting the barrel of my gun
People run out of their doors with the first light of dawn
Not to miss out from the heavy bag across my shoulder
Now rabbits stand still in my front
hands held high in confrontation
Monkeys throw seeds at me as I walk by
Bush pig chase after me
People lock tight their doors
Eyes look away from the flat bag across my shoulder
Me a hunter is now the hunted

Flying

I am flying away
Flying to you
I don't want to be here
Here that they want
Only where my heart is
I want to walk hand on hand
Step by step with you
The only world I know
What matters to me
My heart desire.

On

If I have to move on
Leaving you behind
How can I make it
Alight need a switch
Or will remain dark
A switch need a light
Or will be useless
We need each other

Call

I will always call you my own
Not as object of possession
But as part of myself
Our visions are alike
Words same
Our steps not inline
But same point
It will get us
Time has cheated us
But one of these days
We will sit down laughing at time
Saying where is your power
In your lashing out
You have made us strong
In your pain
You made us victorious
Making our love to see the light of the day
Forcing our dreams to come through

Celebrate

Lets celebrate us
Celebrating life
Marching into a new day
With the gains of yesterday
Letting go the wounds of past days
Its one wish
Oh no two wish
One word
Oh yes two words
Peace
Love
Happy future and everlasting love

Fool

Why shouldn't I be called that
When I beg to breath air
Even water
Not to mention a place to lay my body
Is no ones fault
But money
That have made my laugh
Even my talk
Word of a stupid benign
I have walk when others walk
Took the same train to the city
Stop at the same station
Mine has been a foolish benign drop
Wait oh
The day will break
Tomorrow will come
My purse will full
The tag fool
The word stupid man will be gone
It will now be intelligent benign

Why

Why me
Question
No answer
Just life
Let go
If not tested
How can you find your strength
It's a mystery world
No place for the weak and helpless
Only those who's strength
Can carry trough all odds
As to see a better day

Goodness

Our goodness will always walk before us
It will shield us
We will fall
But it will lift us
Be wounded
But it will heal us
Inflicting double of our pains
On those who took advantage of our goodness
Sometimes forcing us to ask
does
It worth it
Yes it does

Hope

Hope took me down this path
There will be a branch out
The end will be the lost coin
Eco so strong
So what?
So what?
Even if you find it.
They that found
What happen?
Those that live with it
How far?
You are not those
Harmer back hope
Yes I am deferent
The coin belong to me
The end of the search
The rise to the high
Just what was missing
You
You.

Chance

So blind have you gone
That you can't see this
How depress are you
That you fail to take this chance
Is this desperation
You step on it unnoticed
Or have confidence took over you
That what matters,
Matters not
Sit down for awhile
Let go just for a minute
Its all elusion
If those you envy
Will be truthful
You will see the pains they live in
Lets still give it a chance
Lets not ask whose fault is it
No one is perfect
We all have our short comings

Waiting

I have waited
Almost giving up
Have been swimming in the darkness
Tears my pillow
Pain my companion
Just then you came
Bright as a morning star
Your light touching all sides
Showing the way forward
Giving it new meaning
Gum tears melting away
All pains gone
Its place over whelm by joy
Each step empowered by love
Thanks for the transformation
Thanks for the hope restored
Thank you for the life saved

Will

No matter how cloudy it is now
Faith I have in you
Faith in this love
Faith in our fate
In its roughness is a hidden sweetness
It will rain washing away all ill feelings
It will shine
This time brighter than before
We will win
Lets keep faith alive
Medicine of winners.

You

I will always find you
Swim along with you
You are the only world I know
Where my joy flows
Nothing can separate us
Don't have to ask
Will you always be there for me
In me I know you will
But been human
Please always be there for me

Joy

I sit here smiling
Is this madness
Ask those that walk by
The smile is thinking of you
The past so sweet
Love that will ever live on
Lingering forever
Joy that will never die
That joy is you

Point

We left here
Here we met again
Even when we have turned our back to it
Hoping not here
Praying it's somewhere else
Here because it holds something
Nothing can change

Wing

I look up to the sky
Spreading my hands as my wings
Letting the wind carry me on
To you
My hope
A shoulder to learn on
Where everything is ok

Fair

This coin is my share
The idea is my
The first move my
That coin makes yours more than mine
That's life never a fair move
Someone always win
The other feeling cheated

Be

I watch as he spread the cloth over the bed
Half covered
Top wet
Down stained
Remembering
What you give is what you get
As you lay your bed
So you will lie on it

Trade

I can trade my life
My joy for love
Knowing it will replace it
Ears not to hear ill words about you
Not my mouth as to say I love you
Not my eyes as to see your beauty physical and internal
I can trade all
But not love

Pride

How can I sing this song
Where will I start
When pride have block my throat
Not letting me say I don't know how
I only heard of the title
Words I don't know
Song elusion
It would have been I don't know
Please teach me
Just saying show me
Pride
Downfall of human

Don't

Hold back not
Free the mind
There is the handicap of one
Over coming the mind is victory
To conquer the world

Again

Again money
Yesterday money
Yes it makes the world go around
But love makes life go on more than anything else
Cheap to get
Comfort it brings
Money comes and go
Love last forever
Money comes with fear even of one self
Love internal trust

Feel

If only you can touch my heat now
You will feel its fast beat
Beating for you
Touch my face
You will feel the tears of joy
All for you
For giving me this chance
Just that chance to prove my love
I know its real
Disbelieve me not
What I feel for you is real

Nothing

Turn your back not
Answer me or not
Our part have cross
Nothing can change this
No matter how fast good times flies away
Leaving anger and even fear of approach
We still have and share something
Very precious that not even time can take away
You know as I know
We will cherish this all the days of our life

Choice

My choice is clear
Can be seen from afar
Heard from way beyond
Echoing like the desert wind
Immeasurable is my love like desert sand
Radiating as it's morning sun
Strong as it's afternoon heat
Cool as it's night breezy
Our dark side overwhelmed by joy
Brought by hope and love.

On

I live on saving my love for you
Walking through these thorns
Life has never been fair to me
Never given me my heart desire
But I have been hopeful
Strong through these thorns
Knowing somewhere out there
I will find that everlasting love
It will take away my pains and sadness
Then you came
Once in my life I am happy
I brace up to conquer the world
Looking into your eyes fire me up
Empowering me like a lion
Well now prepared
Because of you by my side

Sweet

My heart beat has never ceased to drum
From that day I set my eyes on you
You energize my benign
Drawing all the element of nature
Far and around to my disposal
You are such a sweet
That makes life worth living.

Angle

If there is a season
There is none better than now
When the tide is high
Plants so green
To say I love you
You are so natural
Very unseasoned
You are the garden and kinder of my life
If I don't say it so often
I am sorry, your are an angel, I love you.

Quest

Shouting alleluia
He walk down the street
It rain on him
Stop on him
The sun rise above
Set over him
All that walk by shook their heads
Tears fell from some looking at him
Many went as far as saying
What is all this
Quest for money
Quest for wealth
But that quest forgotten
As his eye closed
Breath stop
Lying down on the walkway.

Seed

It's like a seed place under the soil
Growing out so tall
It's branches shading from me all sunlight
Blocking breeze from reaching me
It's root spreading all-round dip down
Sucking away all left water leaving me dried
Breaking all the walls I have carefully build around me
Leaving me so vulnerable

Temtetion

It came blowing gently at first
Sweet as never before
Hope like it has never been
Then like all things
Just one fault
Two fault
On and on it comes
Blowing as if it will never end
Can fall an Irock
Uproot a rock
Then it stopped like all things
All will always end
Carry on move on like it matters not

Comfort

I have hope on this
Believing one day
I will dance with you
It may not be as my own
In my soul you will ever be
Once again laugh before your face
This laugh I will ever carry along deep down my soul
Laugh it when I am cold
When loneliness comes
When confront by hopelessness
Knowing as I laugh it your comfort
will cover me lifting me up
All will be well again

Design

It has all began with a world
A touch so magical
I am not a great architect
My design is my true feeling
Build from hope to hope
Into a solid foundation
Wall with trust
Painted with devotion
Lightened with my will
Anchored by my heart
Here we have reach
Is a work of two heart
Now strong from destruction.

Overlook

I am a rocky land
Dried and over looked
My touch stains
Entrance wounds
Judged barren looking physical
Then you came in watering my soul
Flowing from my feet up my head
Bringing out the life in me
Making me ever green as equatorial rain forest
Flourishing like the bank of the Nile
We became inseparable
Me a home to flow
You a source of life.

Planned

I dance watching the eagle pitched on top of my hurt
It slip falling before my feet
Making me jump up in rejoice
Lunch and dinner is assured
Only to find out it's roughened inside
I touched the back still strong
Lunch and dinner can still be savaged
Out of nothing can still be something
In life what we hope for
Hardly can be achieved as planned.

Peace

He stood with a red eye
Sorry was all that came from his mouth
Looking down as he walked away
That was yesterday
Today a bleeding foot from a falling glass
You pushed the table
I am sorry how,
How much is the glass?
Even knowing is not his fault
Sorry brings no trouble
But keep life and peace going

Compaer

The marching band is known to always be inline
Each steps inline
Every beat intone with the others
Each swing inline
Look carefully
Listen attentively
It's never inline
Not intone
As it goes further
Only so fashioned
One hardly notice
Compare me not
Sequence is hardly kept
Just let it be
It will pick up as it goes once the heart is there

Hate

Your hatred has move me on
Your anger towards me
Has force out my will power
Made succeeding a must
Stop and think
What we do sometimes to demoralize others
Hurting others feeling
Help build them up.

Letting Go

Did you enjoy yesterday
That was yesterday
This today
A new day
Not always about money
But joy and love
That this new day
All must fall in place
Life must go on bring joy into tomorrow.

Ask

I will not ask where was I
When the train past
Or when the clock tick
I will not look back
Saying had I known
This is losers song
Winners never quite
I will not say look how far they have gone
Only how will I pass them
Not as a competition
But as a push
To touch the sky
Pass the sky if I have to

Hold

Its like
A want
Just one bottle
To drown this sorrow
This bottle is sorrow
It drown you
Leaving the sorrow flowing
Helping in more mistakes
Did you see yourself?
No
But it sees you
Laughing at you
Saying yes we got him
A place to release our venom
Leaving him no space to think right
As to amend and grow.

Me

It is still me
Gone from my old self
Walk now in shadow
Painted in tears
Living in dreams
Faces turn away as I walk by
Each step taking in pains
Still is me
Believing in change
For change is one thing that is not constant
Still is me
Once there is life
All will change for the best
Holding on to hope
Not letting fate drag me down for so long
It will always be me
I know who I am
Only me knows me better.